300
DRAWING
PROMPTS

Follow us on social media!

Tag us and use #piccadillyinc in your posts
for a chance to win monthly prizes!

This edition published by Piccadilly (USA) Inc.

Piccadilly (USA) Inc.
12702 Via Cortina, Suite 203
Del Mar, CA 92014
USA

10 9 8 7 6 5 4 3 2 1

Made in China

ISBN-13: 978-1-62009-851-6

Angel's wings

Dr. Seuss hat

Your reflection

Asteroids

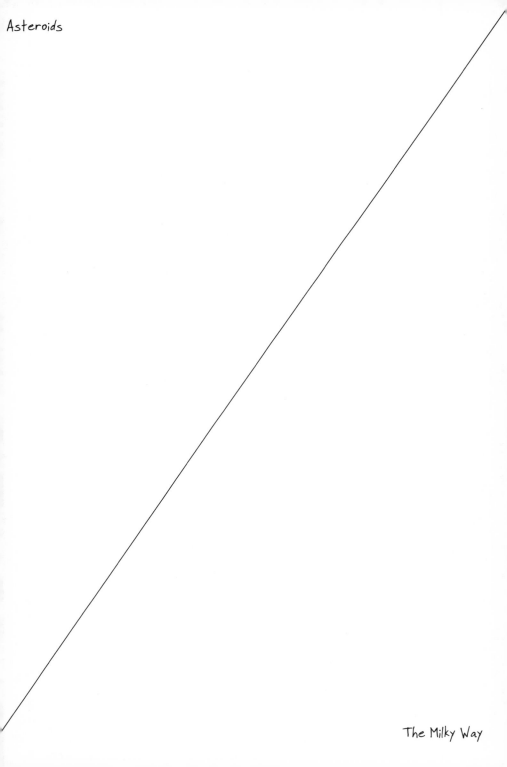

The Milky Way

Comic book cover

Lotus flower

Looking through a keyhole

Tree of life

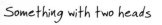
Something with two heads

Light saber | Grim Reaper

Fountain of youth

Man in the moon

Lightning strike

Goddess

Psychedelic portal

A view from the top

Masquerade mask

Poseidon

Jackal

Deer antlers

Medusa

Carousel

Voodoo doll

Tiki idol

Sugar skull

Something abstract

Aladdin's lamp

Tooth fairy

Blue prints

Cyborg

Totem pole

Magic kingdom

Beach scene

Pac-Man video game

Your zodiac sign

Something 3-D

Anaconda

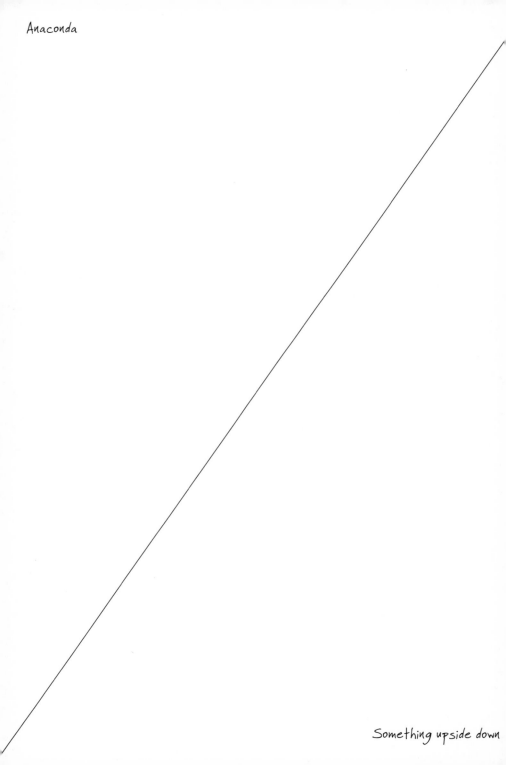

Something upside down

Computer from the future

A bright idea

Grand Canyon

Mad Hatter

Football

Dollar bill

Koala bear

Hummingbird

Woolly mammoth

Giraffe

Wishing well

Bull's-eye

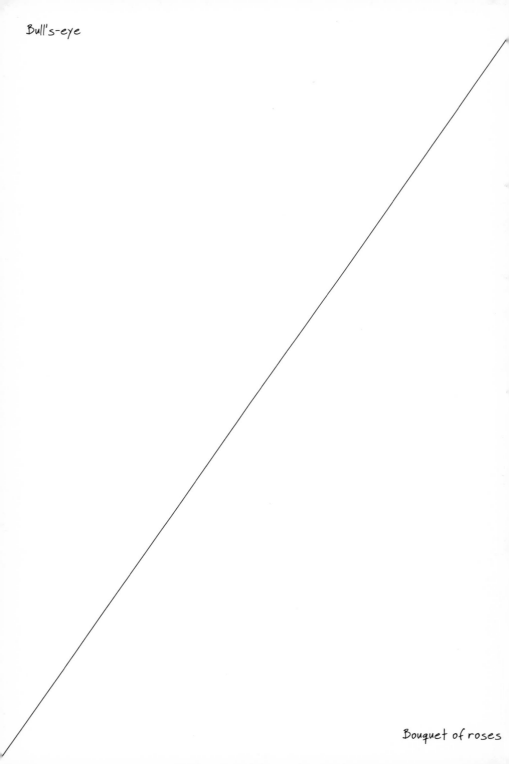

Bouquet of roses

Aurora borealis sky

Boombox

Ticket stub

Captain's hat

Something nautical

Banjo

Bowling alley & pins

Labyrinth

The Kraken

Armadillo

Eiffel Tower

Jack-in-the-box Goblet

Mutant

Weeping willows

Grappling hook

Shepherd

Your country's flag

Water slide

Didgeridoo

Power lines

Olympic medals

Warrior

Stop sign

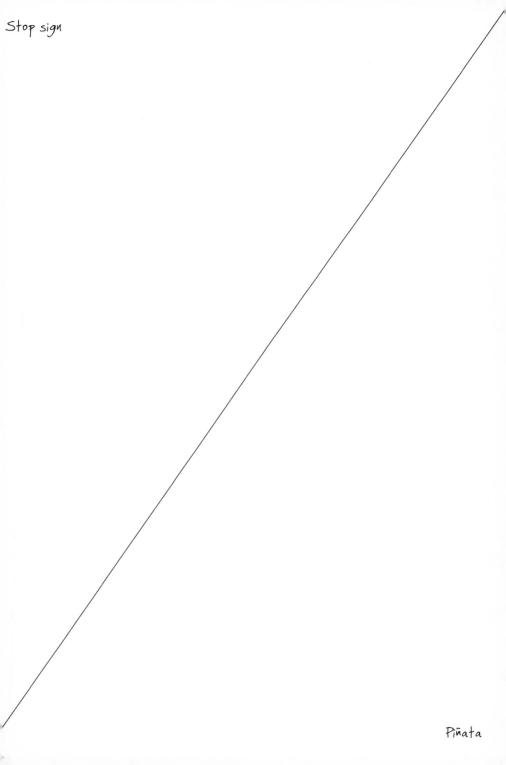

Piñata

Colosseum

Artichoke

Bushel of carrots

Bubbling cauldron

Crystal ball

Alphabet soup

Rubber ducky in a bubble bath

Red Riding Hood

Flamingo

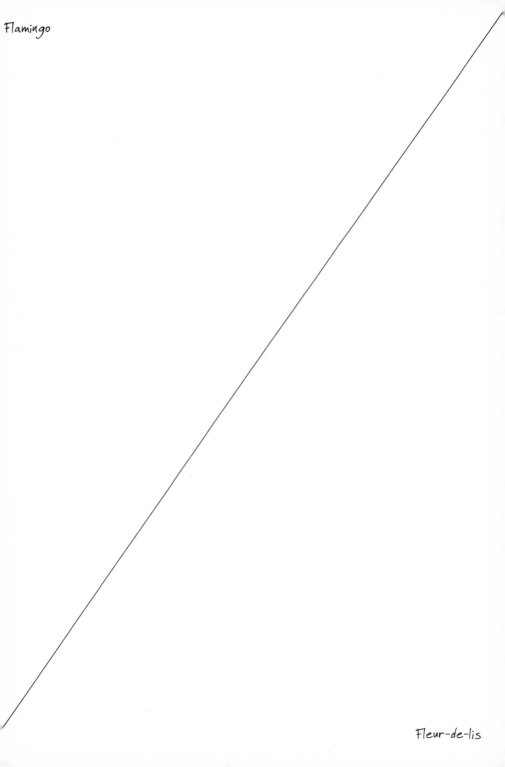

Fleur-de-lis

Noah's Ark

Lit candle

Hourglass

Three Blind Mice

Honeycomb

Compass

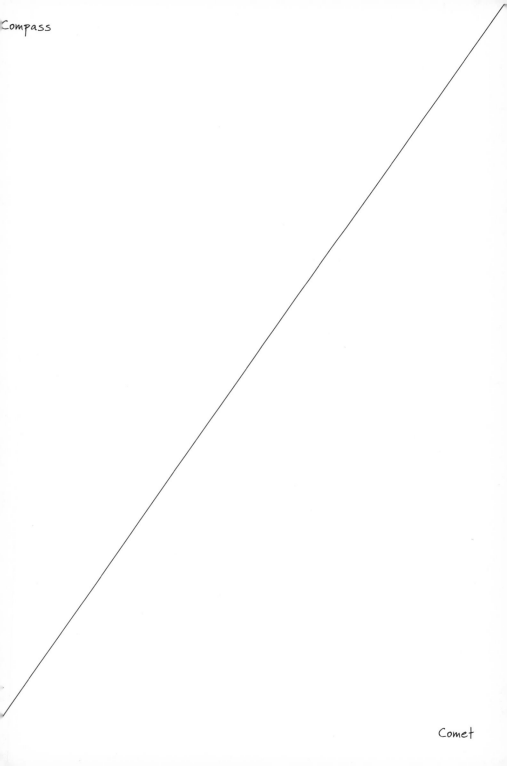

Comet

Snow globe

Stonehenge

Your school mascot

Racetrack

Jungle

Lily pad with frog

Your favorite emoji

Hologram

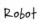
Robot

Hawaiian lei

North Pole

Rainforest

Gecko

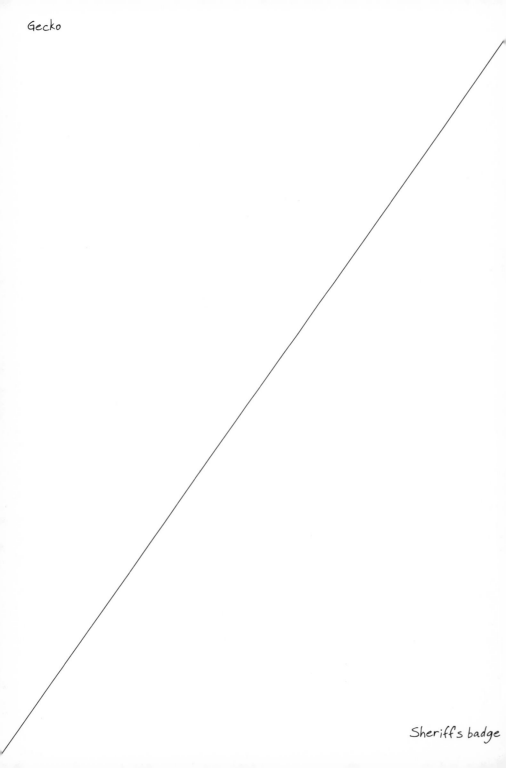

Sheriff's badge

Grandfather clock

Tribal spear

Sundial

Eggs frying in a skillet

Gingerbread man

Nutcracker

When pigs fly

Tacos

Bowl of macaroni and cheese

Your favorite superhero

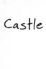
Castle

Talking parrot

Atoms & molecules

Scary cemetery

Stained glass window

Personalized license plate

Charm bracelet

Skyscraper	Sorcerer's wand

Field of sunflowers

Abandoned ghost town

Cool mailbox

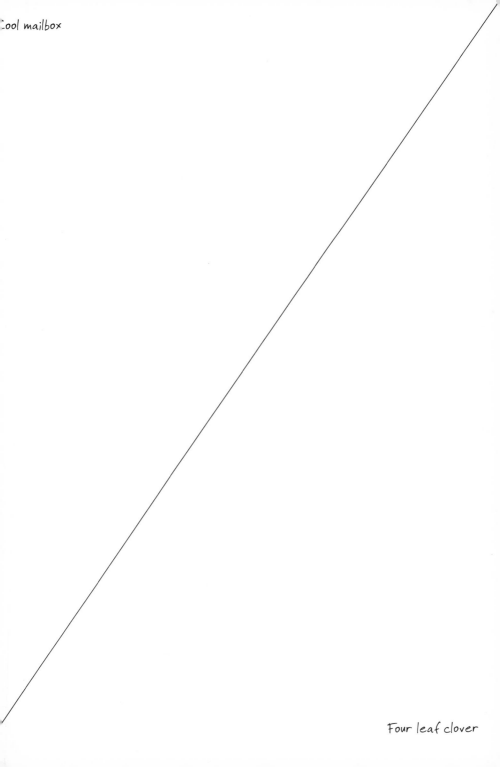

Four leaf clover

Angel

Monkeys

Bumper sticker

Hammock

Garden gnome

Good vs Evil

Peeled orange

Pomegranate center

Giant moth

Snowflakes Parachute

Frankenstein

Science experiment

All seeing eye

Roller coaster

Your favorite cartoon

Kangaroo

Donut with sprinkles

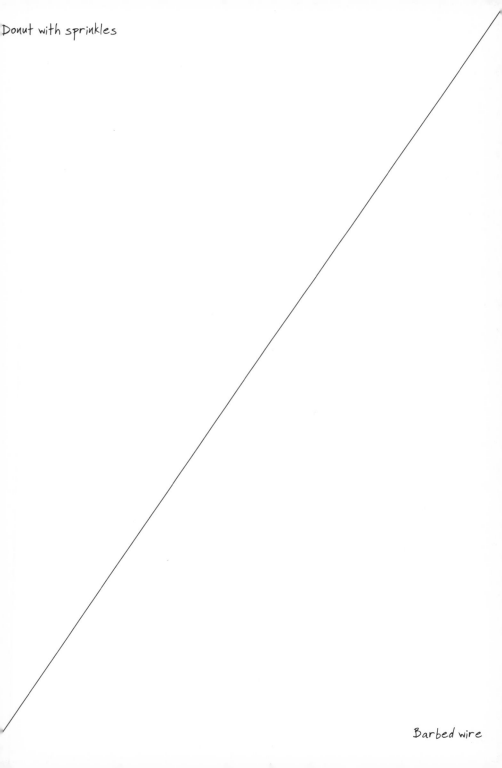

Barbed wire

Treasure map

Pirate ship

Nautical scene

Princess tiara

Sombrero

Fedora

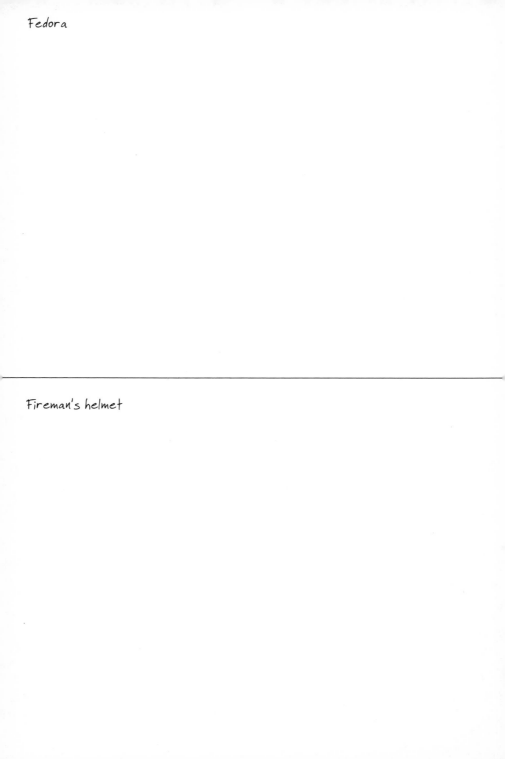

Fireman's helmet

Mandala

Oil rig | Spinal cord

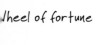

Layers of the Earth

Drawbridge and moat

Chariot

Phoenix rising

Wrecking ball

Phone booth

Egyptian pharaoh

Exit sign

Old pocket watch

Cocoon metamorphosis

Brick wall

Tire swing

Perfect garden

Ball and chain

Dove

Henna tattooed hand

Cowboy boots

Moccasins

Bird's nest

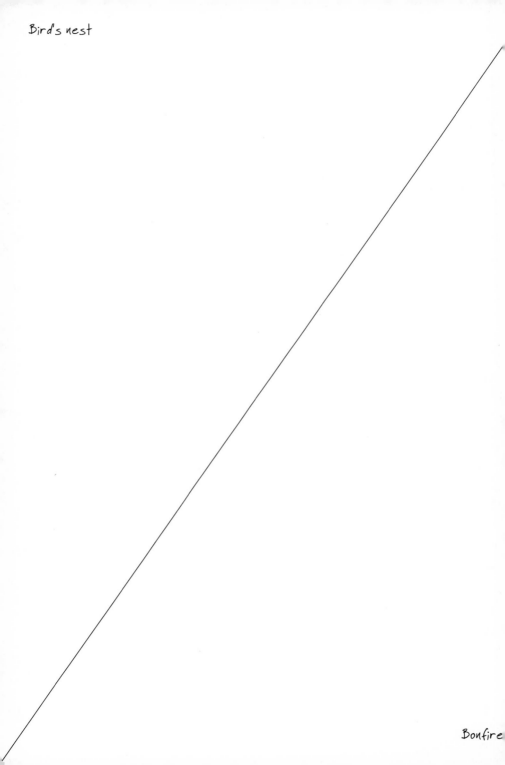

Bonfire

Aquarium

Battleship

Army tank

Dungeon

Dragonfly

Tarantula

Carnival

Crocodile

Catfish

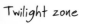
Twilight zone

Mansion

Jester's hat

King's crown

Spartan

Trojan horse

Haunted house

Box of crayons

Megaphone

Mohawk

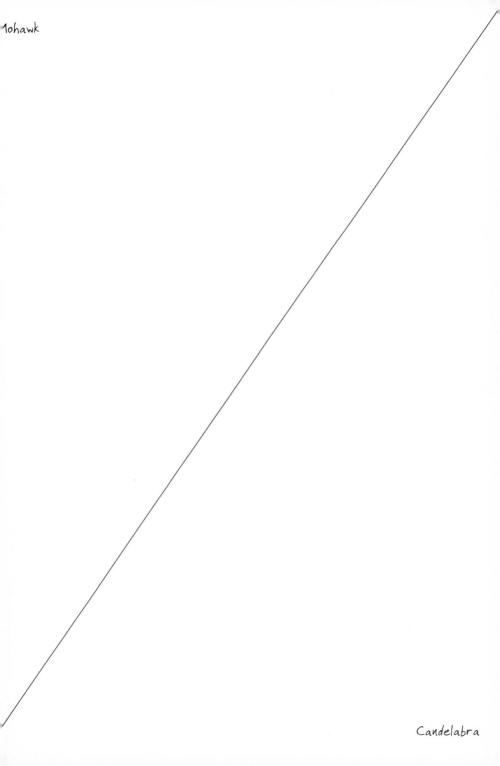

Candelabra

Dream car

Rainy day

Tugboat

Ship's anchor

Dreamcatcher

Cobra head

Rusty truck

Potato head man

Cheshire cat

Polka dot bow tie

Party hat

Barracuda

Piranha

Coffin

Scary shadow

Maze

Conch shell

Great white shark teeth

Utopia

Brass scuba helmet

Lobster

Cherry blossoms

Park bench

Hula dancer

Slice of pie

Something bohemian

Something bursting into flames

Chandelier

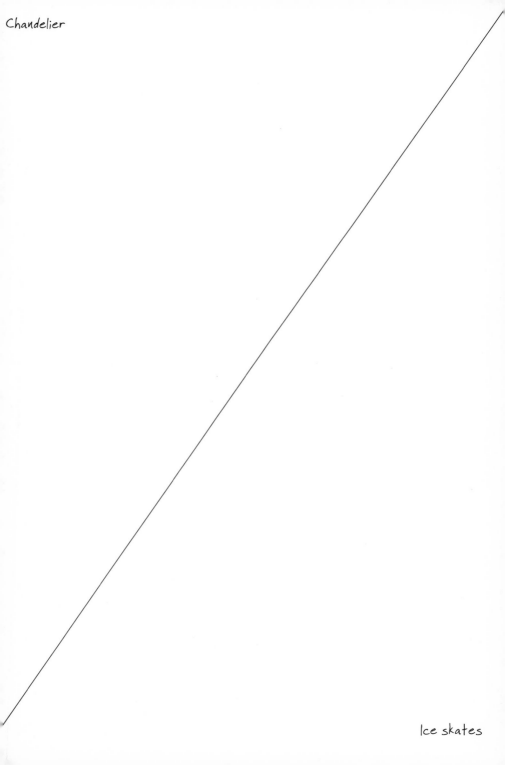

Ice skates

Tree roots underground

Locket

Class ring

Kimono

Nerdy glasses

Solar system

Fireflies

Witch's brew

Wooden clogs

Cassette tape

Celtic design

Boomerang

Centipede

Dark alleyway

Locomotive

Something imaginary

Baseball diamond

Leprechaun

Internal clock mechanisms

Santa's sled

Satellite

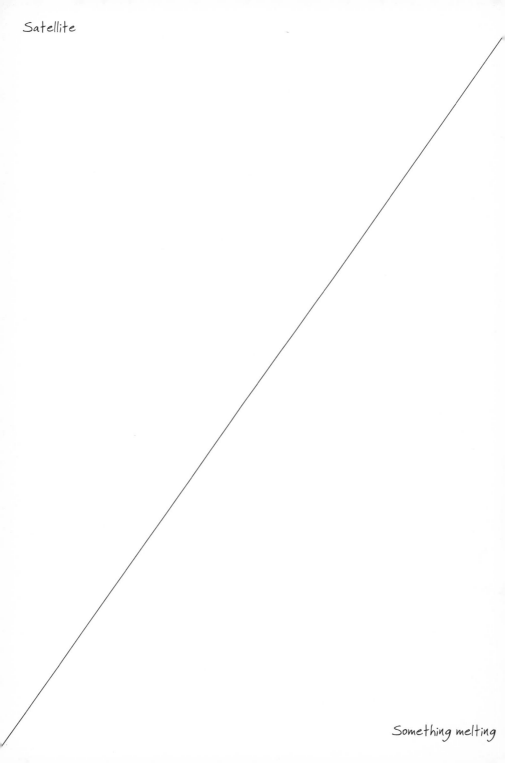

Something melting

Palace

Padlock

Dart board

Factory

Inside your refrigerator

First place ribbon

Quilted blanket

Maracas

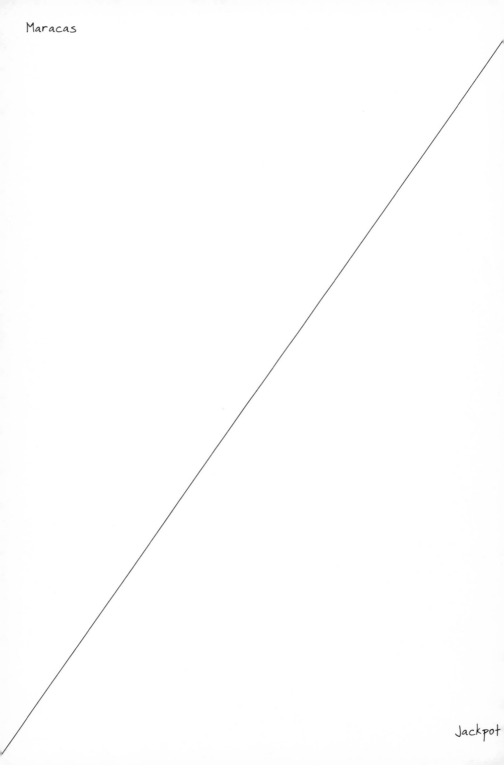

Jackpot

Star constellations

A nightmare

Tiger claws

Titanic

Your favorite logo

Famous sign

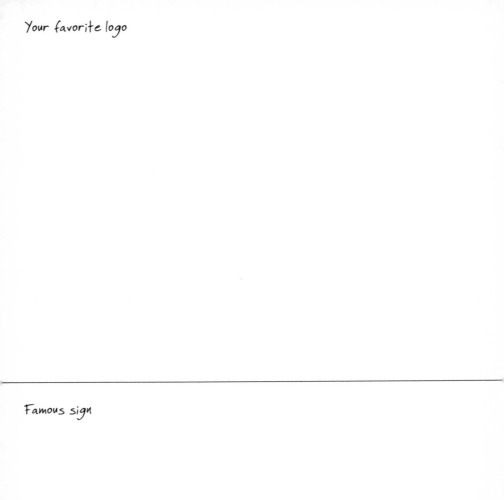

Rastafarian

Laboratory

The Abyss

Poker chips

Loaf of bread

Wild animals

Phases of the moon

Roulette wheel

Orchid

Biplane

Banana split

Laughing donkey

Something funny

Your closet

Dream house

Kaleidoscope

New cartoon character

Time capsule

Panda bear

Something futuristic

UFO

Postage stamp

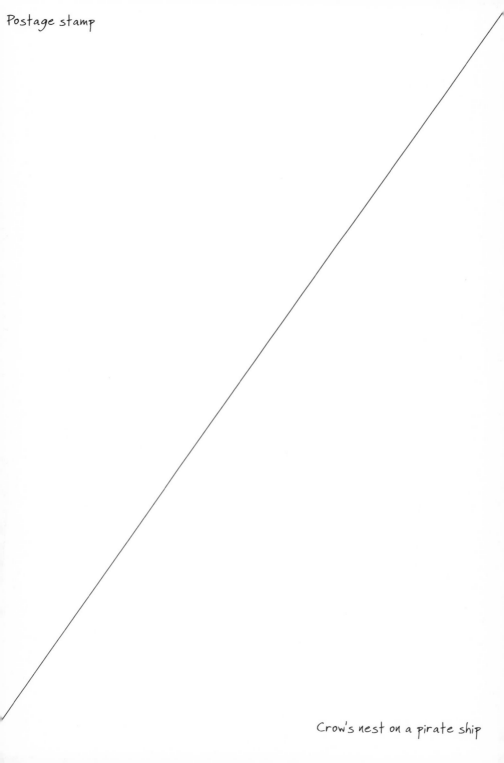

Crow's nest on a pirate ship

Purple people eater

Sunset

Coat of arms

Excited face

Lucky dice

Animated martian

Circus tent

Skyline